# The Organic Coloring Book

# The Organic Coloring Book

25 Original Drawings for
Your Imagination and Health

Doris Sandy

Copyright © 2016 by Doris Sandy.

| ISBN: | Softcover | 978-1-5144-4494-8 |
|---|---|---|
| | eBook | 978-1-5144-4495-5 |

All rights reserved. No part of this book may be reproduced or transmitted in any form or by any means, electronic or mechanical, including photocopying, recording, or by any information storage and retrieval system, without permission in writing from the copyright owner.

Any people depicted in stock imagery provided by Thinkstock are models, and such images are being used for illustrative purposes only.
Certain stock imagery © Thinkstock.

Print information available on the last page.

Rev. date: 02/08/2016

**To order additional copies of this book, contact:**
Xlibris
1-800-455-039
www.Xlibris.com.au
Orders@Xlibris.com.au
732958

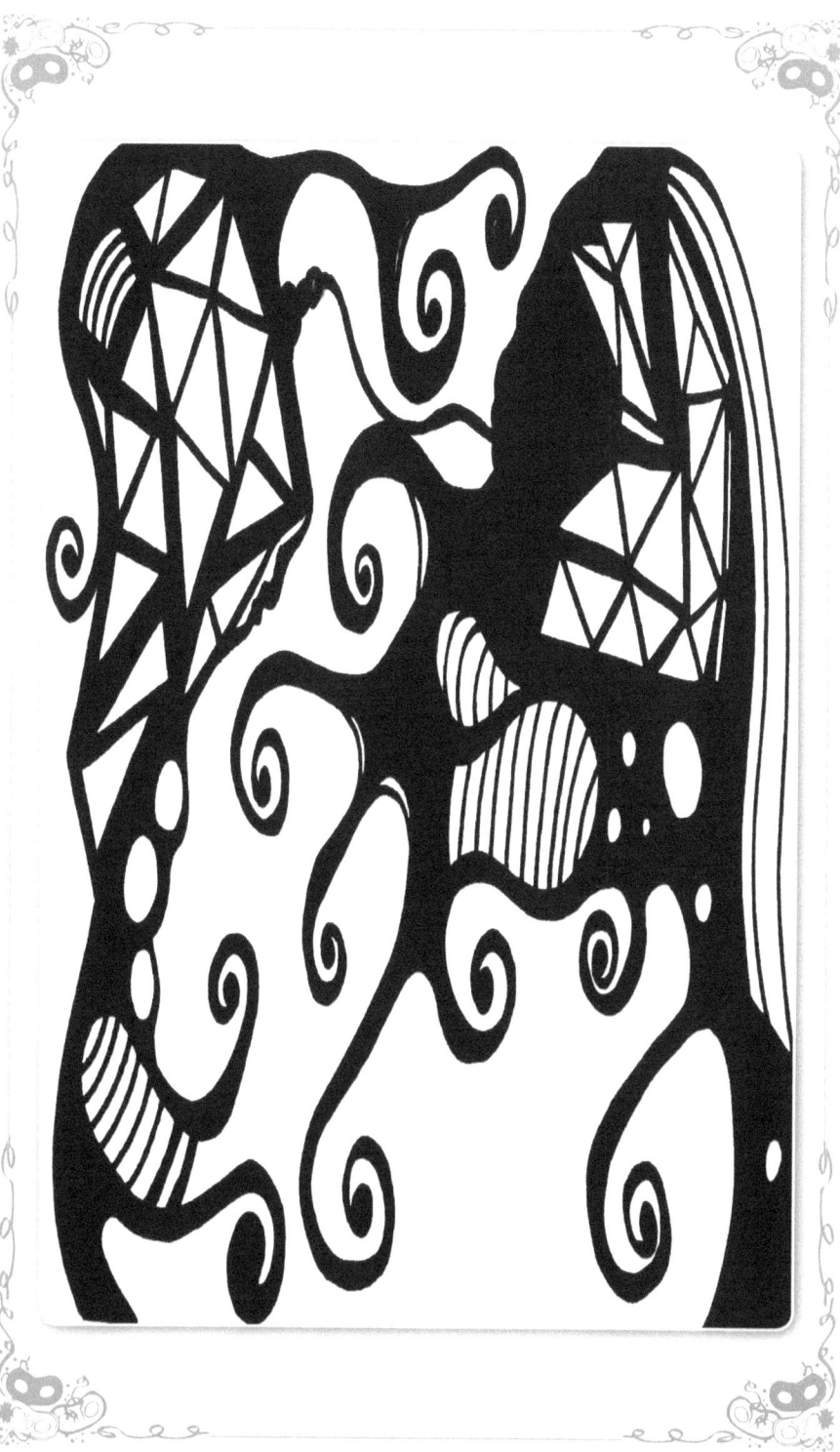

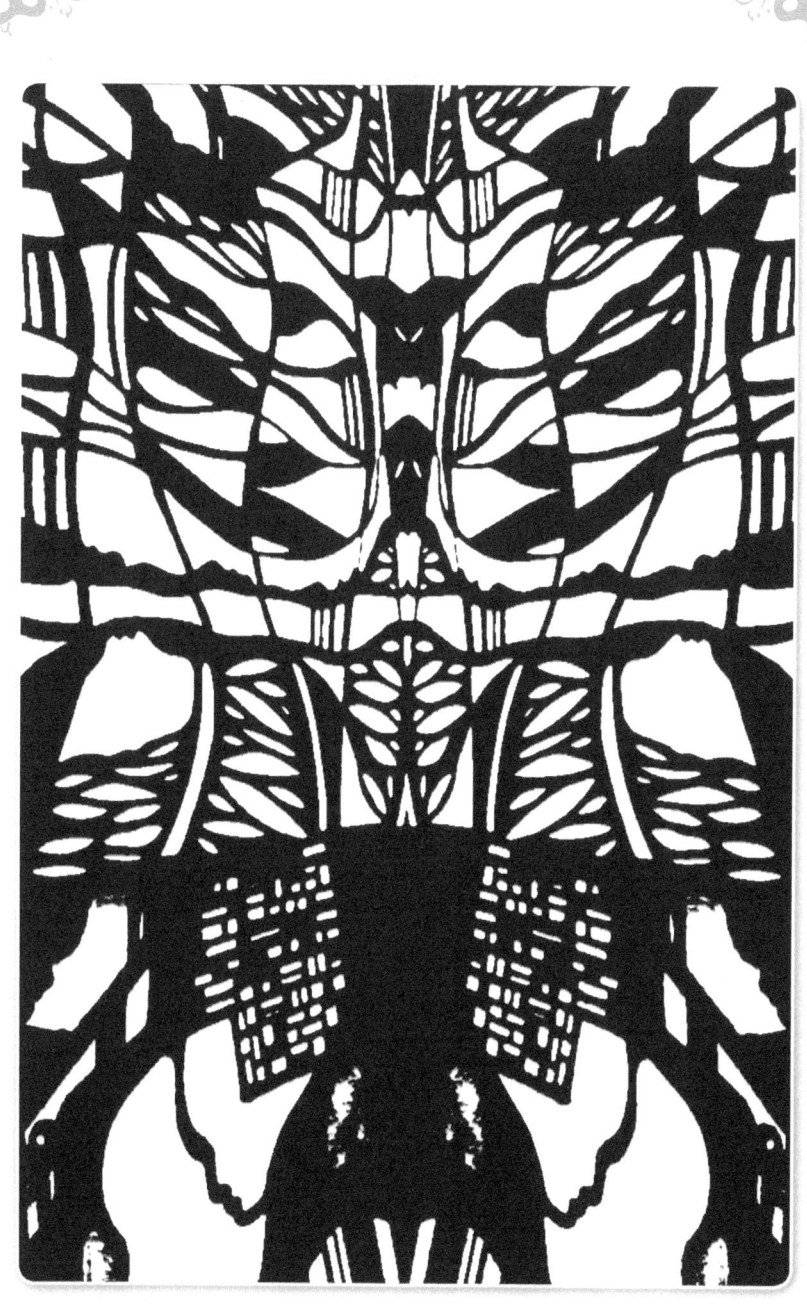

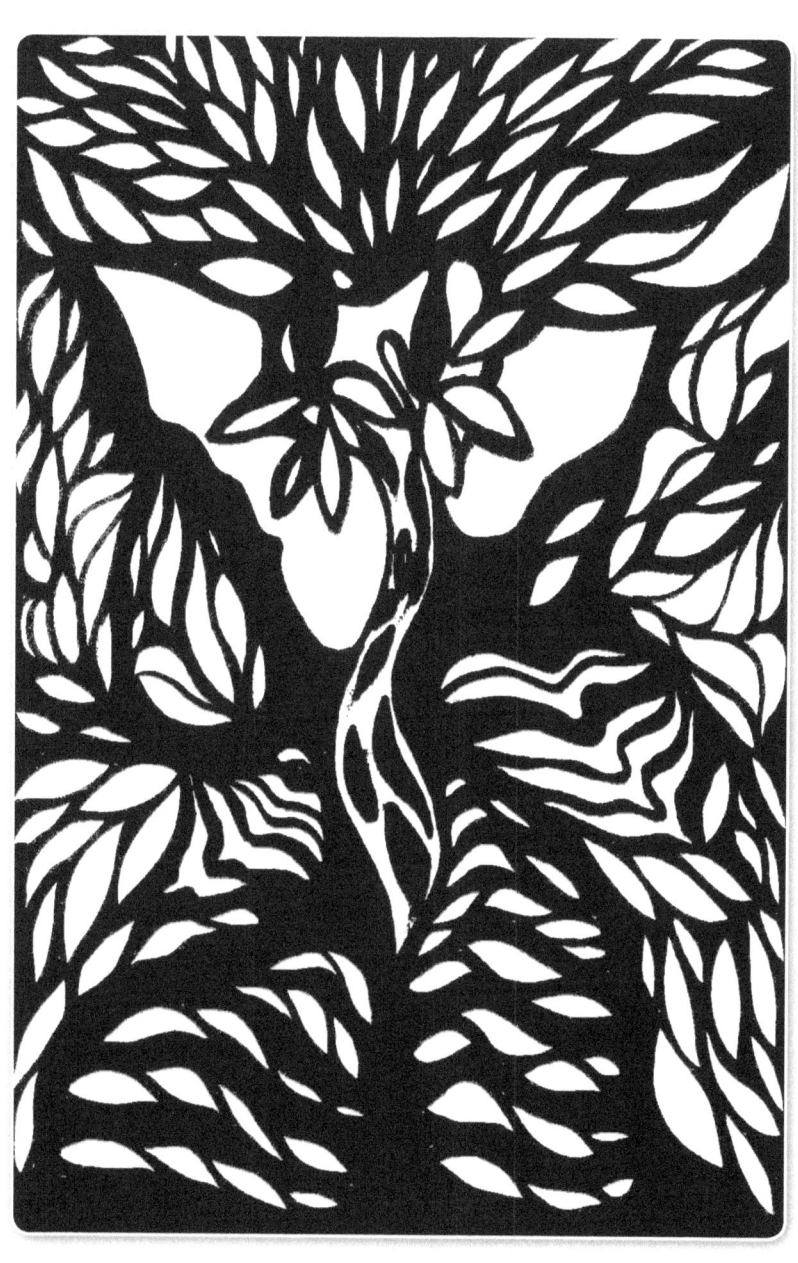

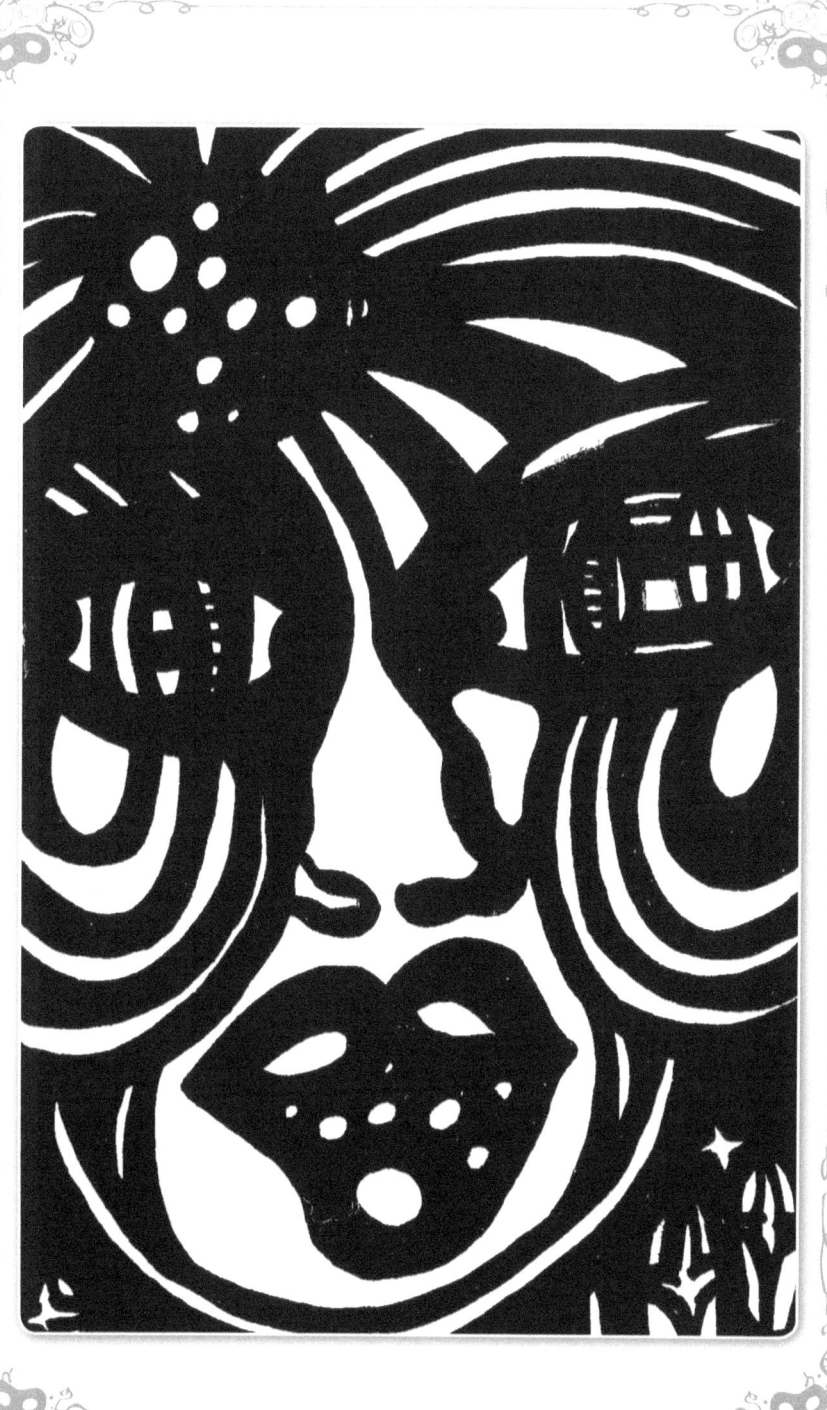

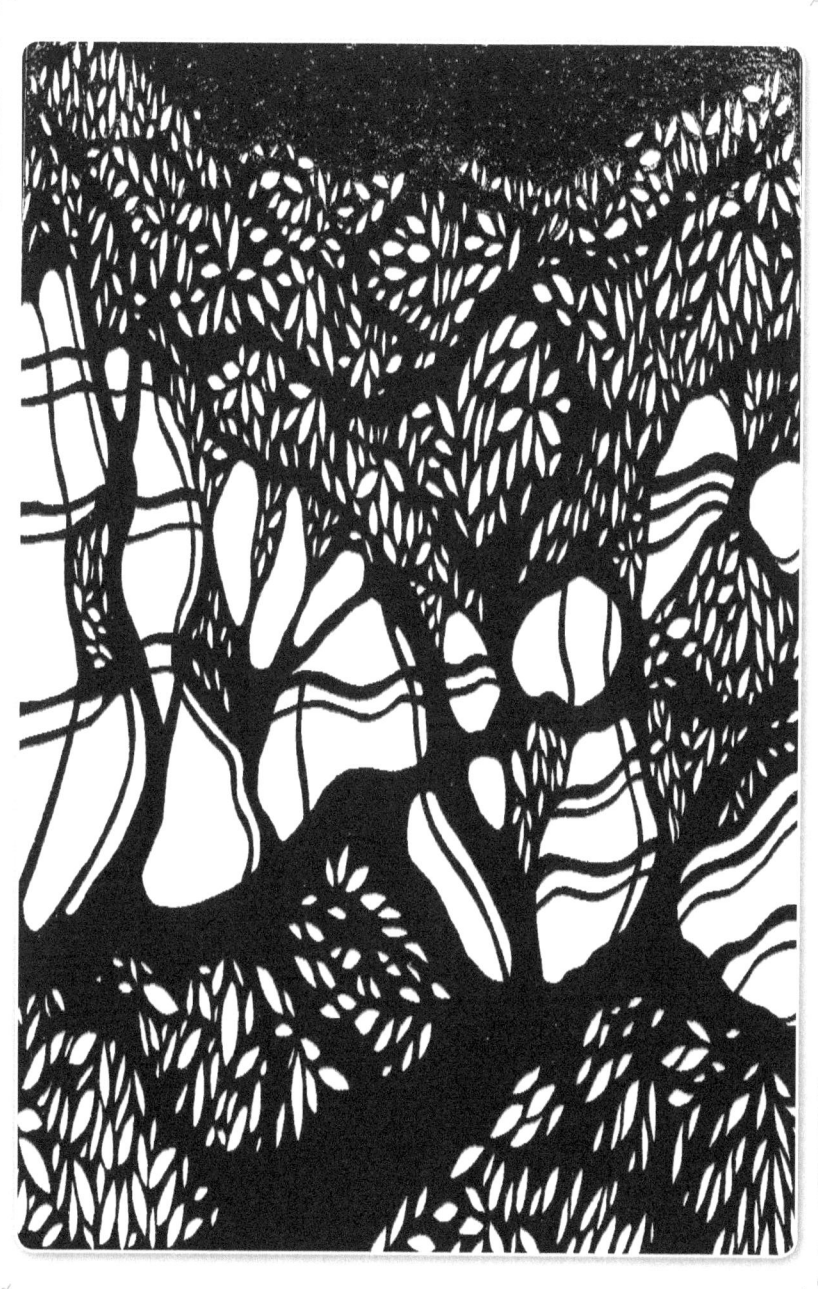

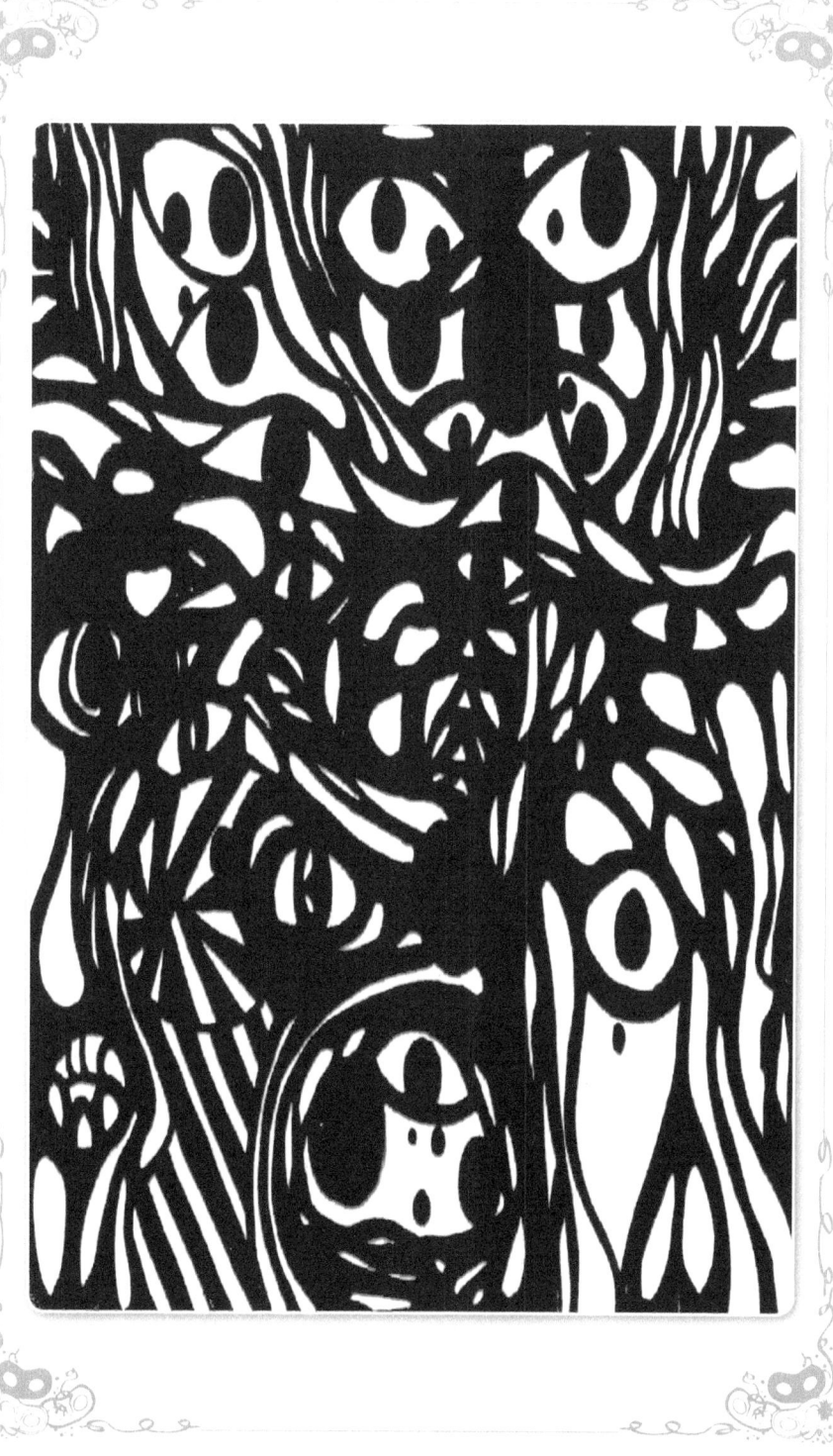

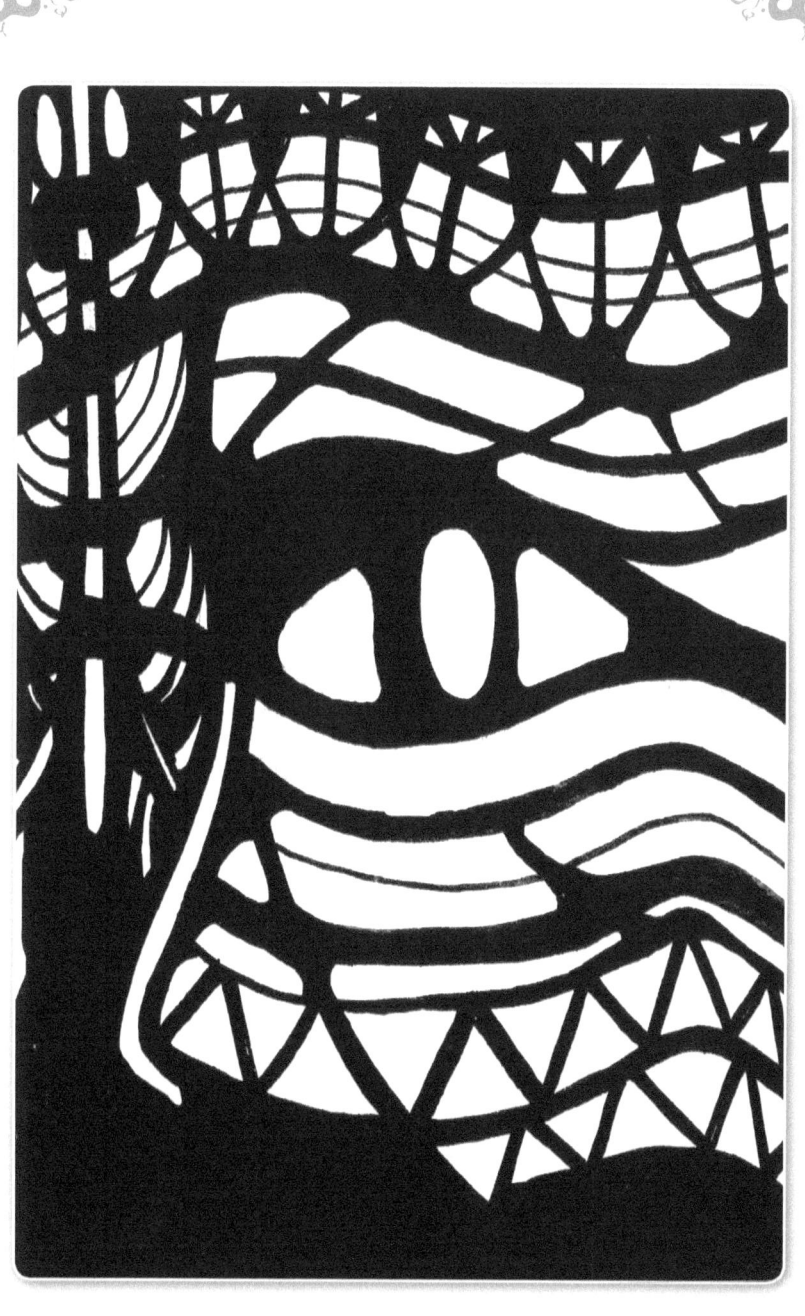

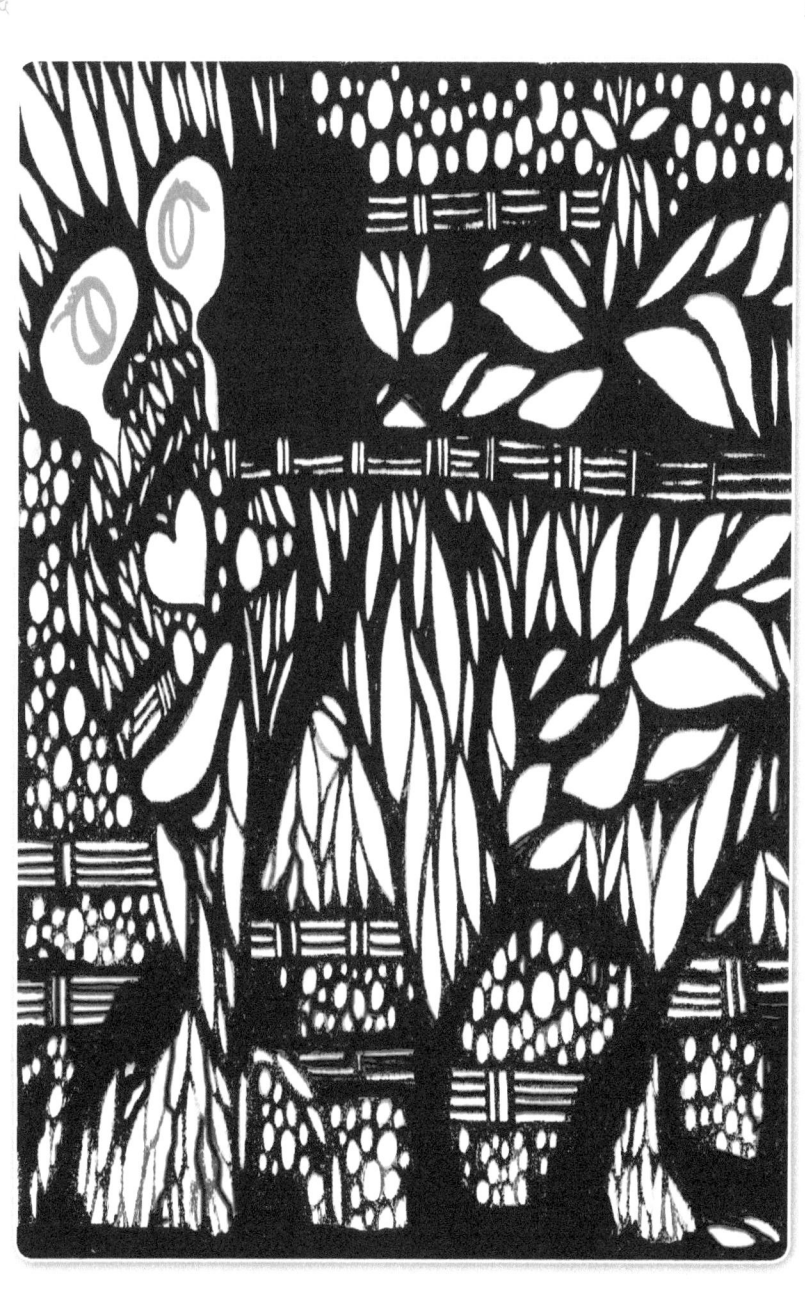

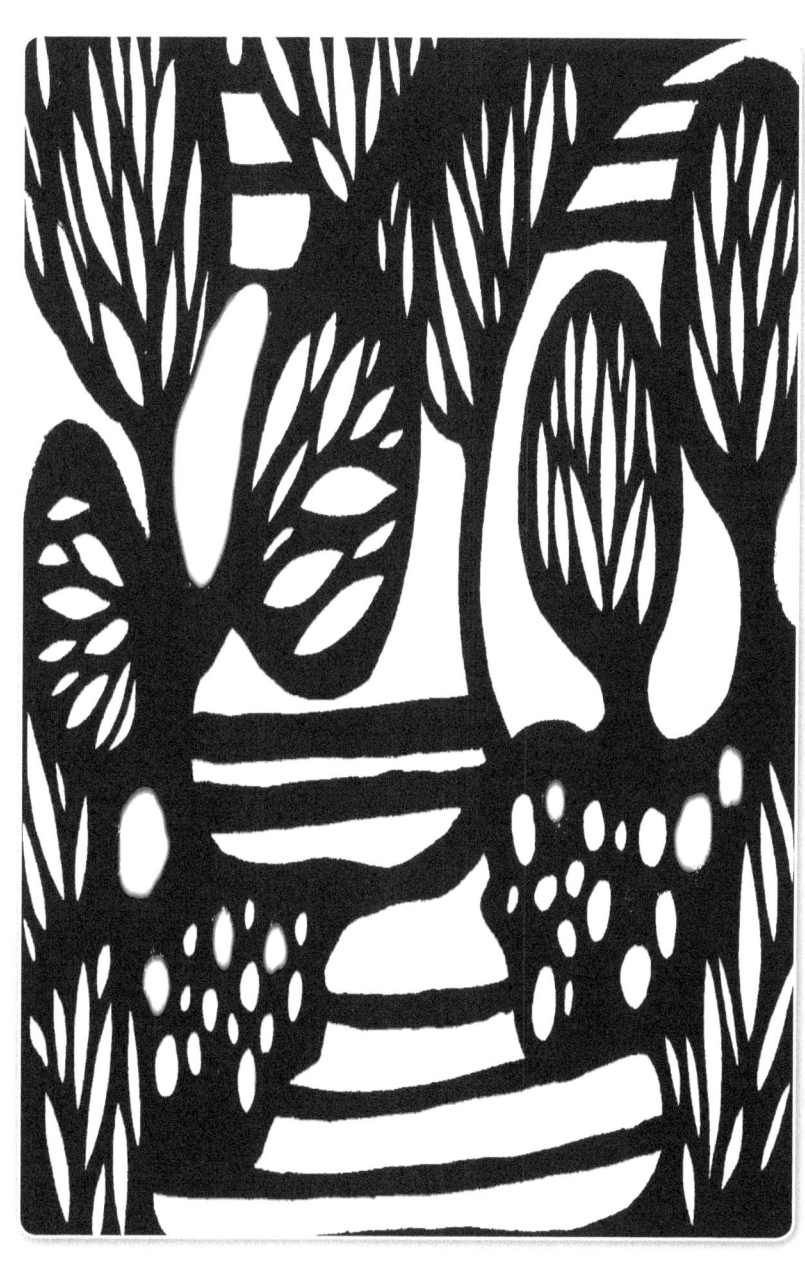

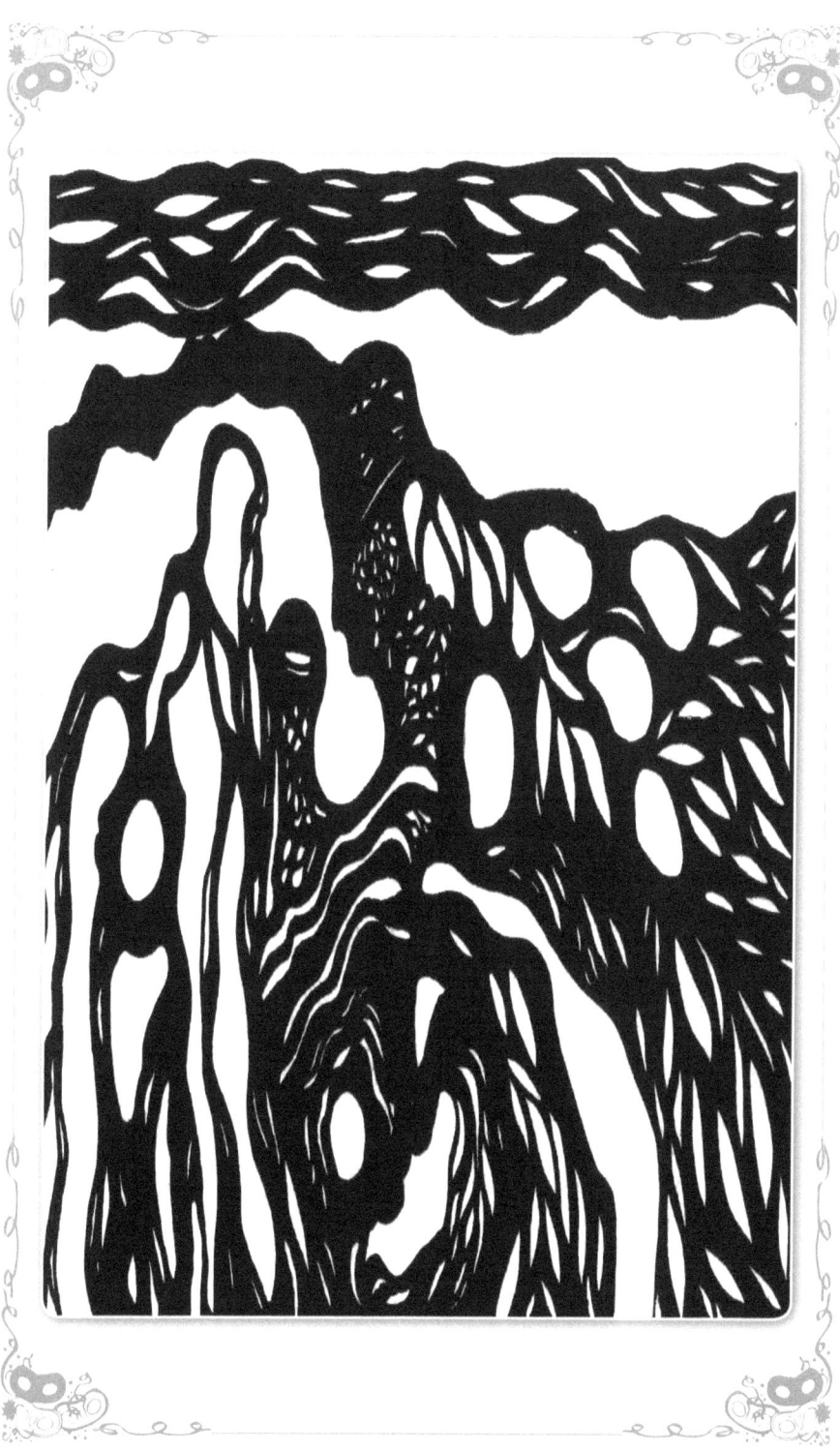

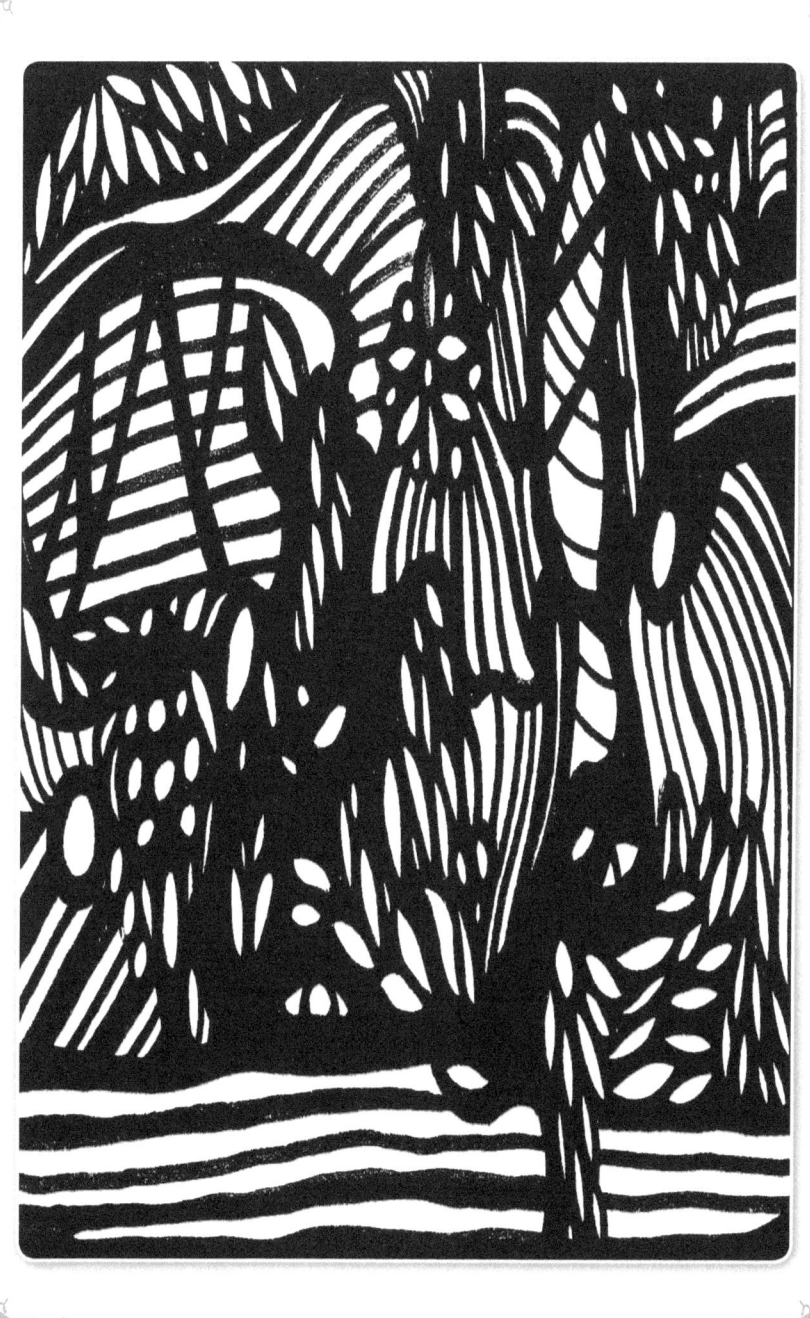

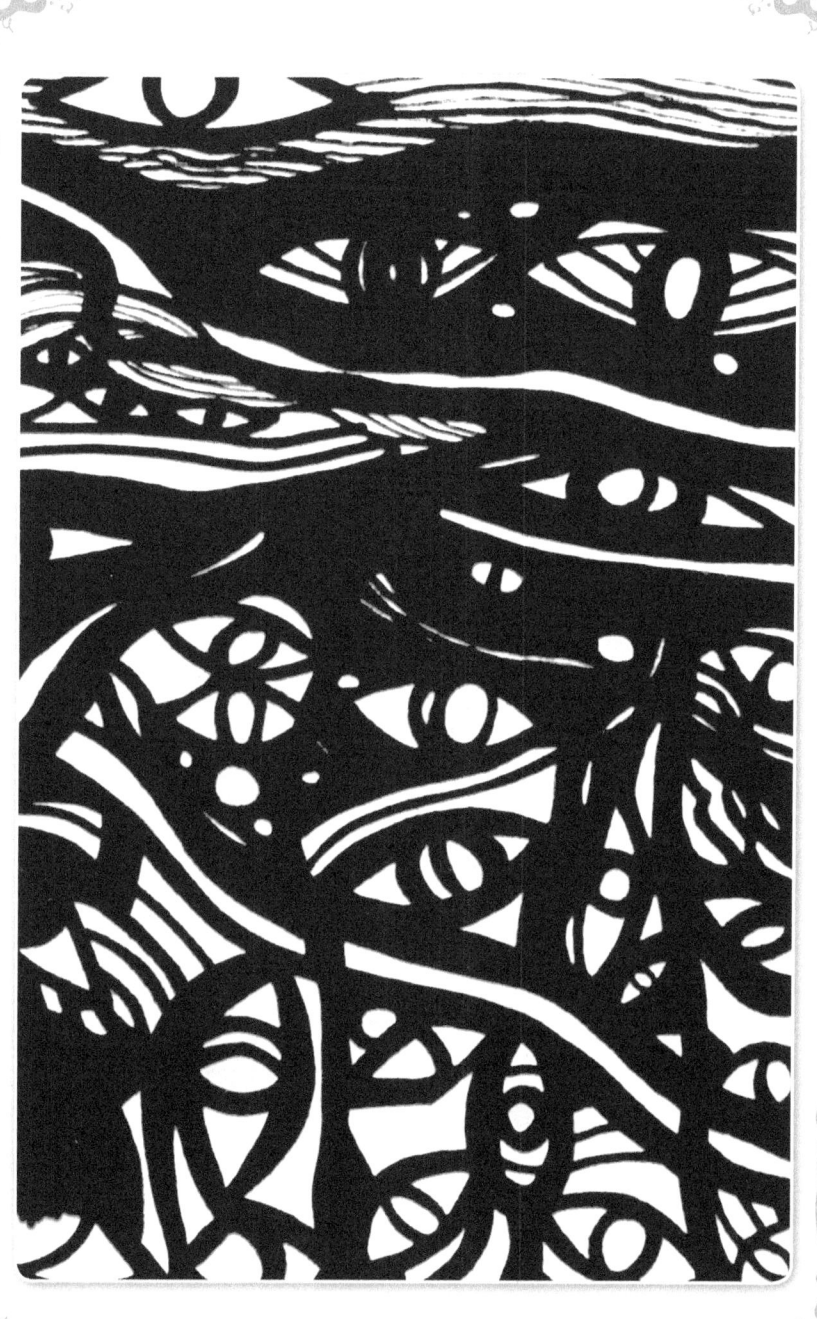

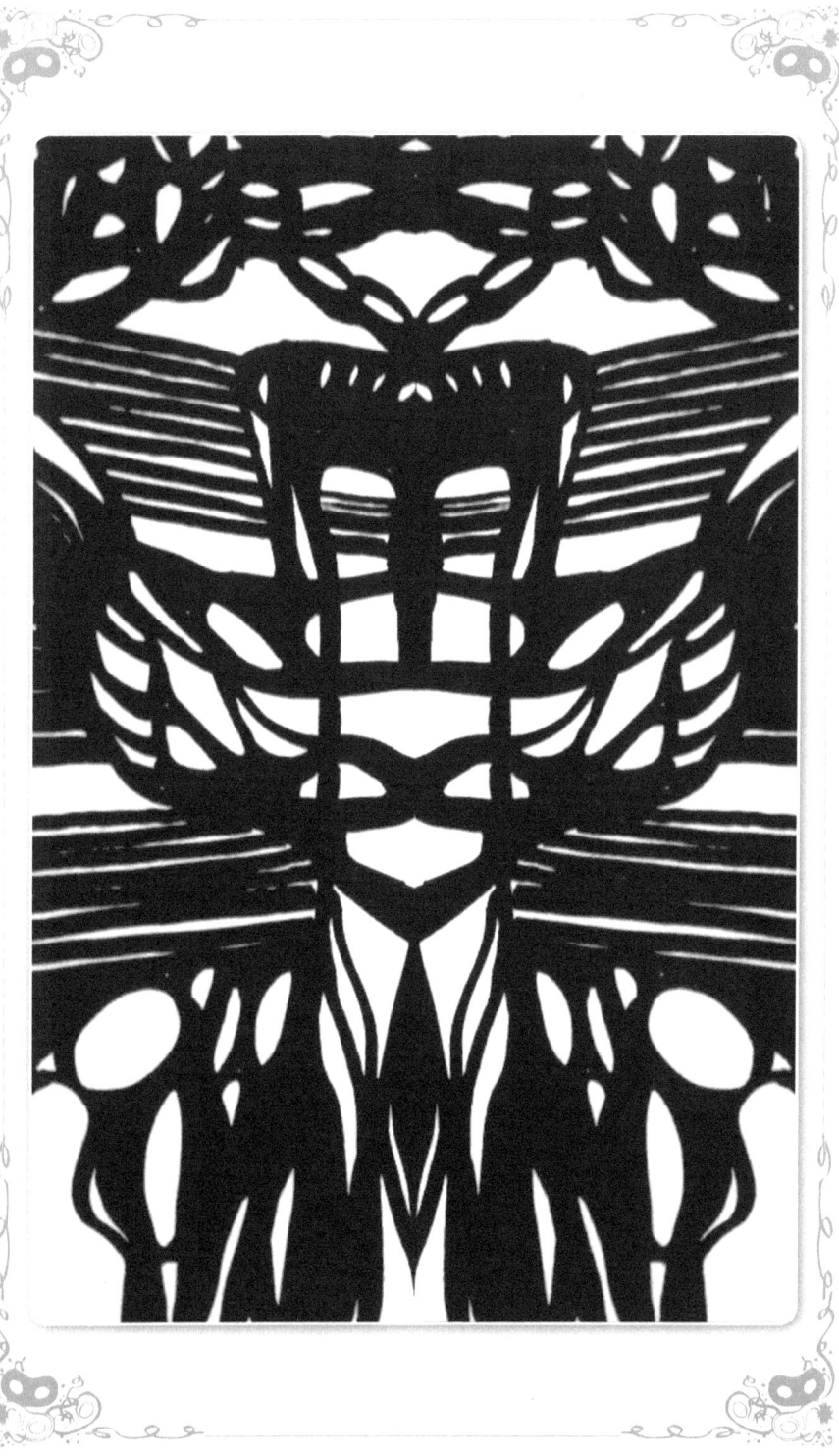

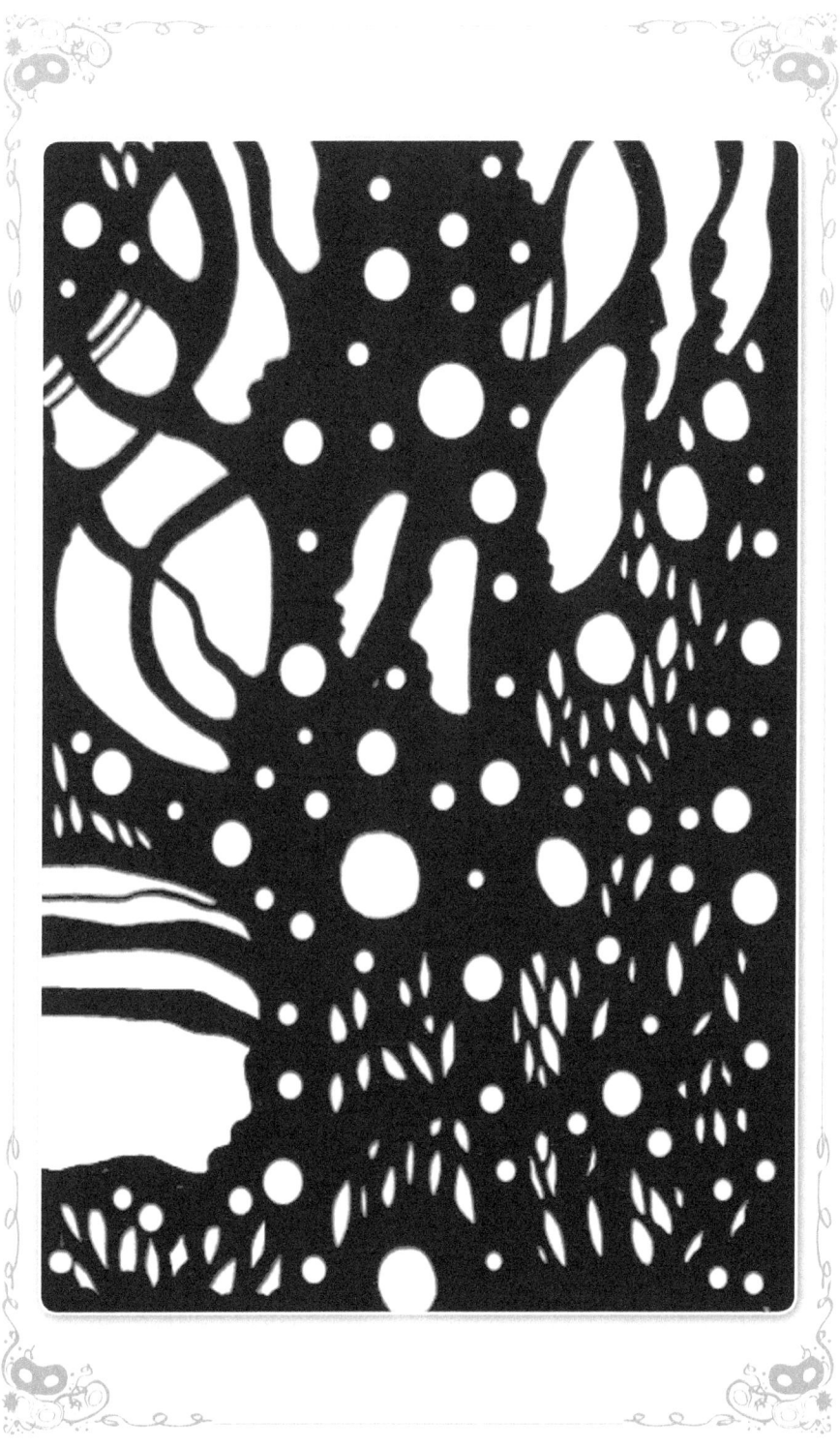

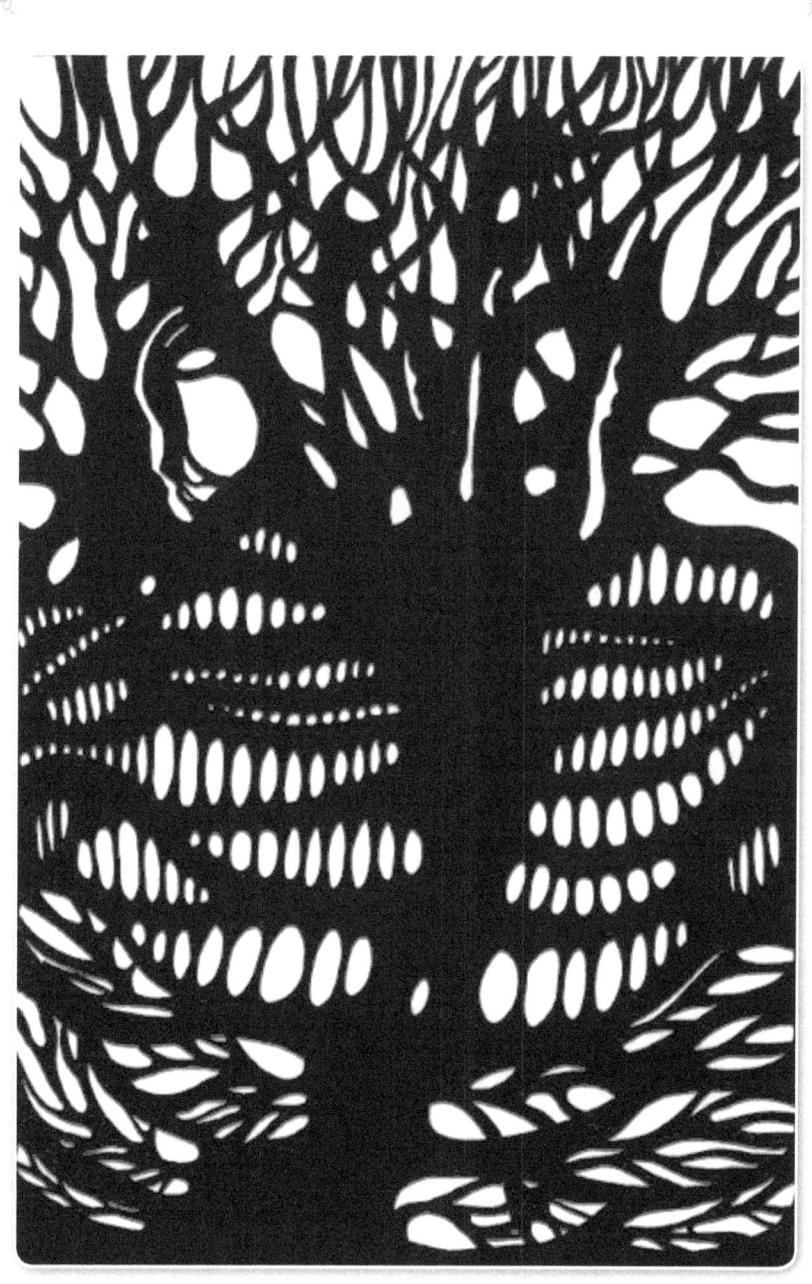

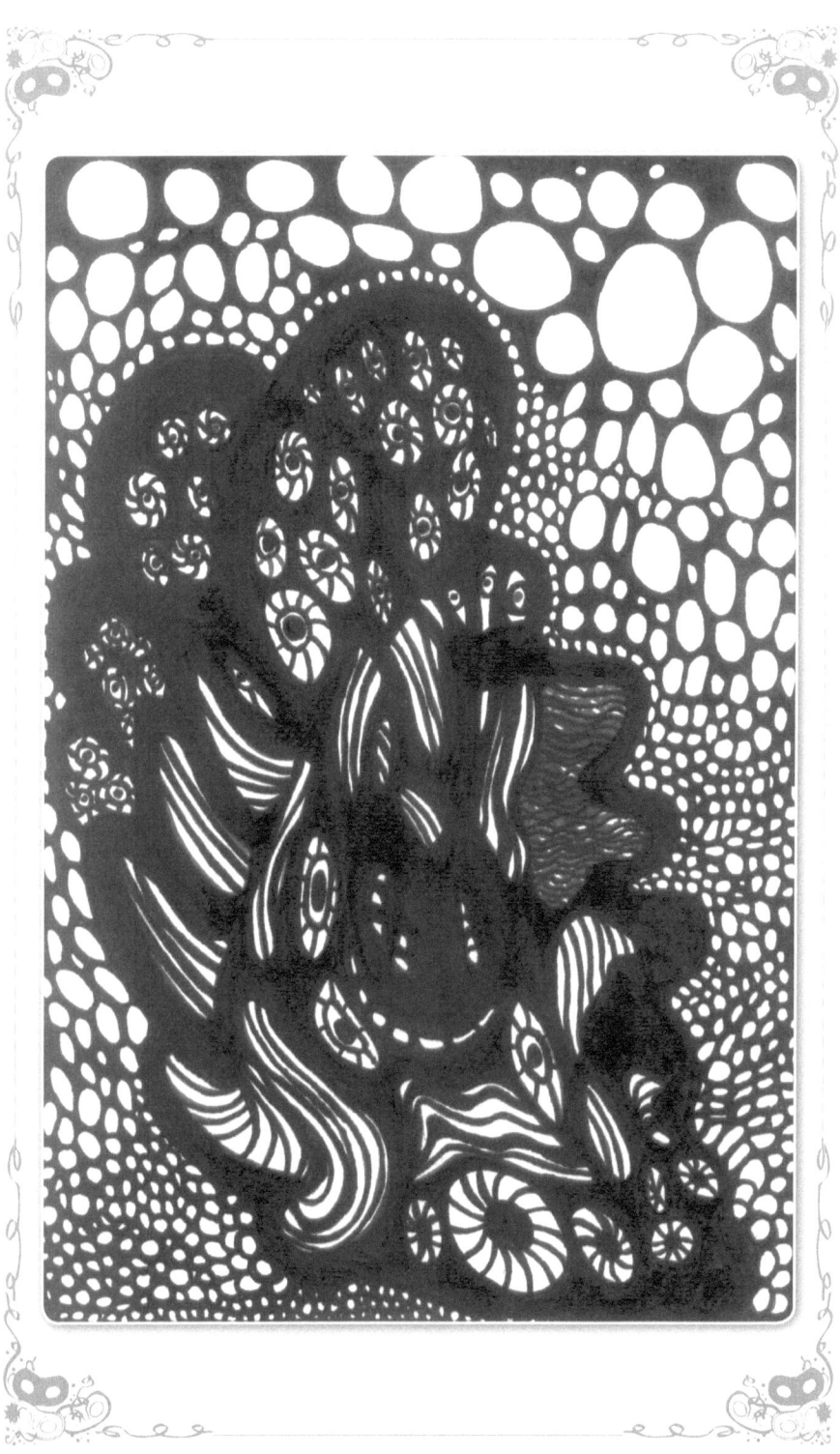

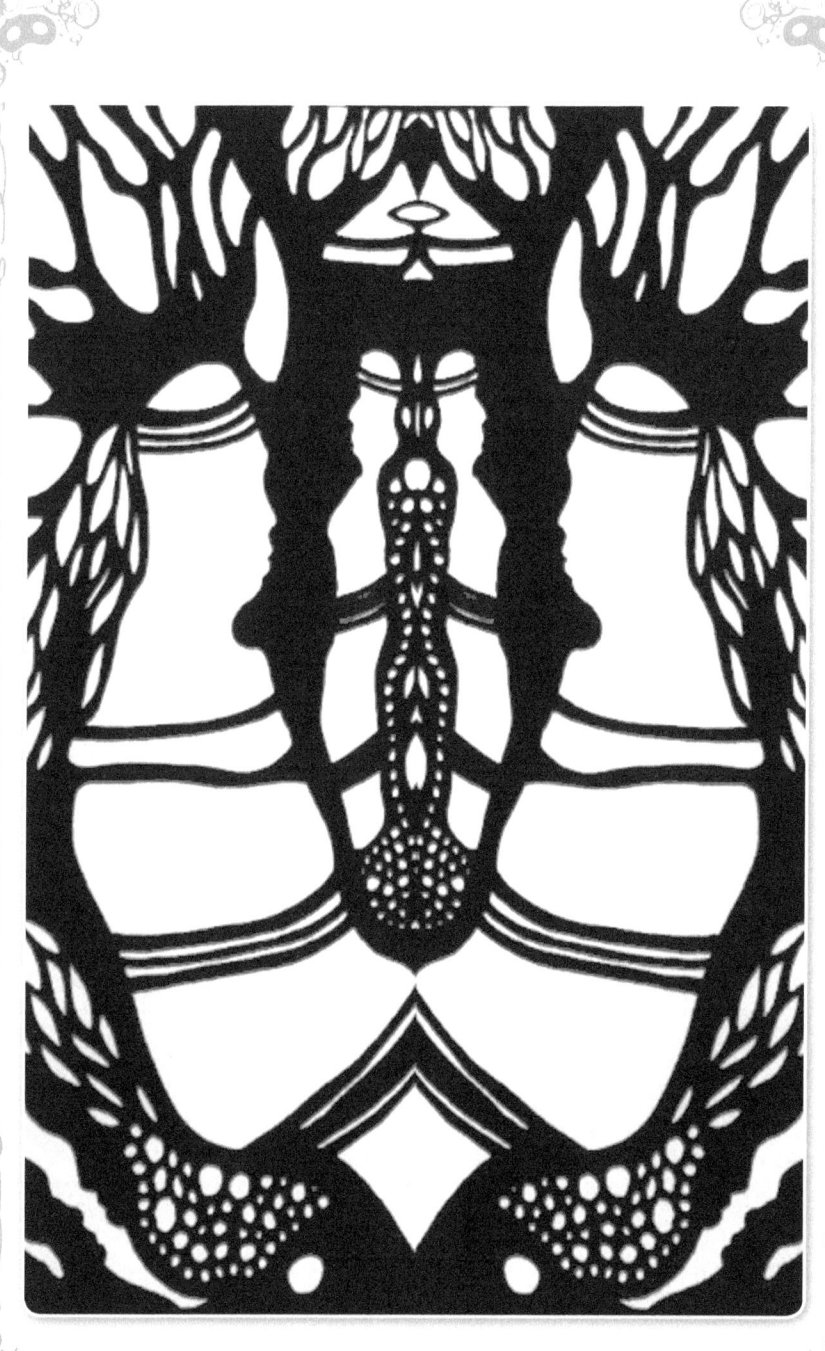

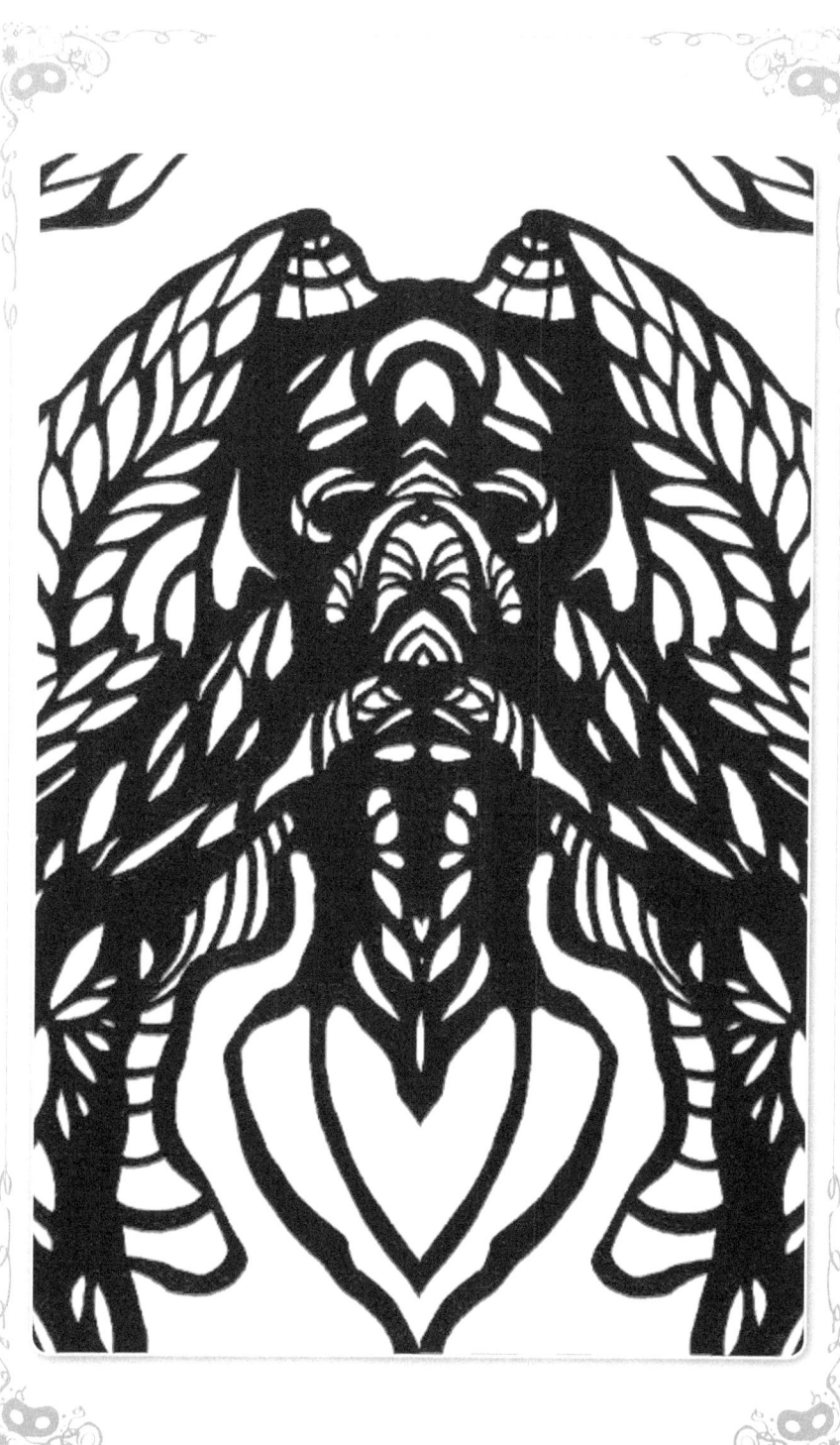

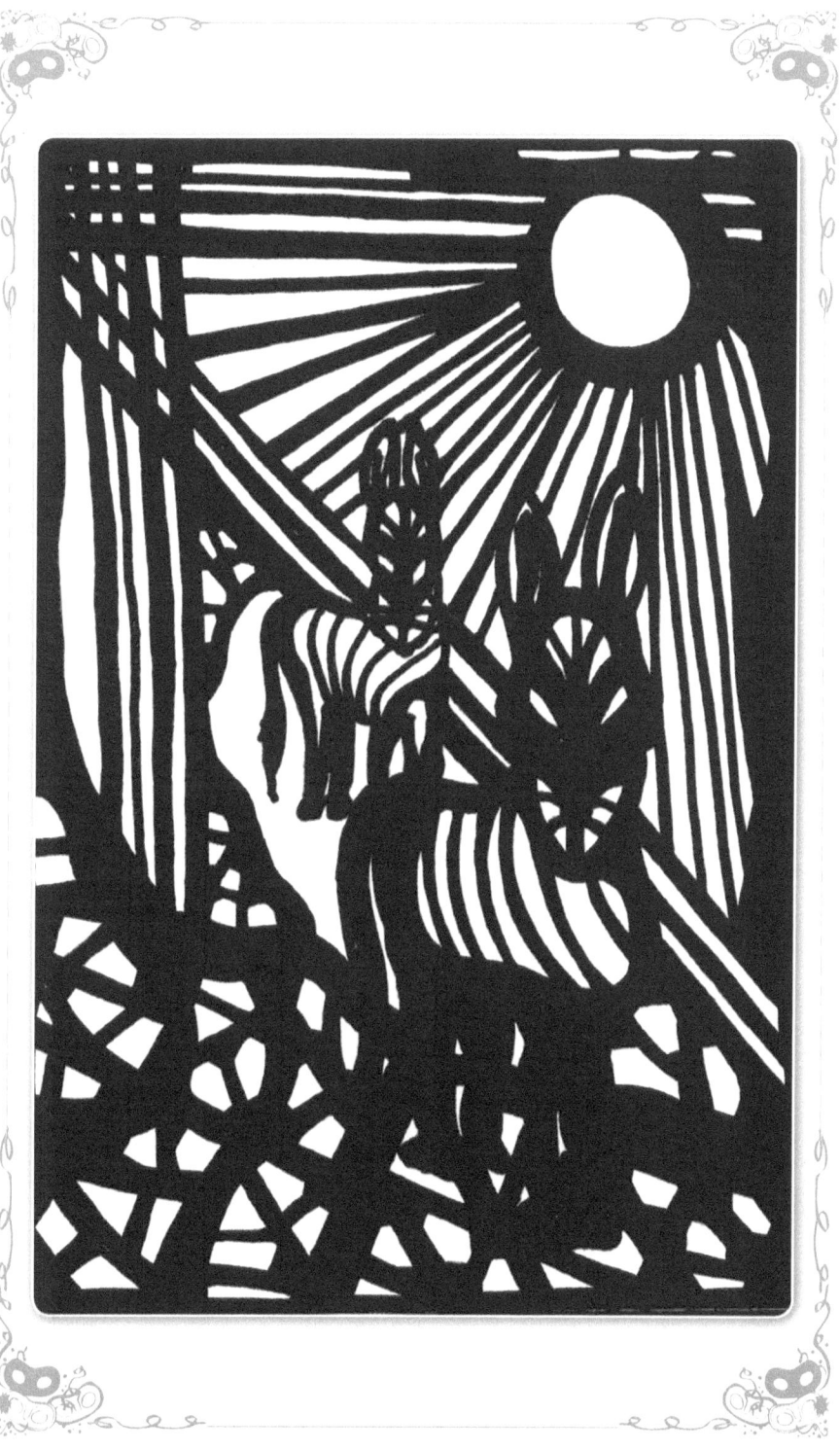

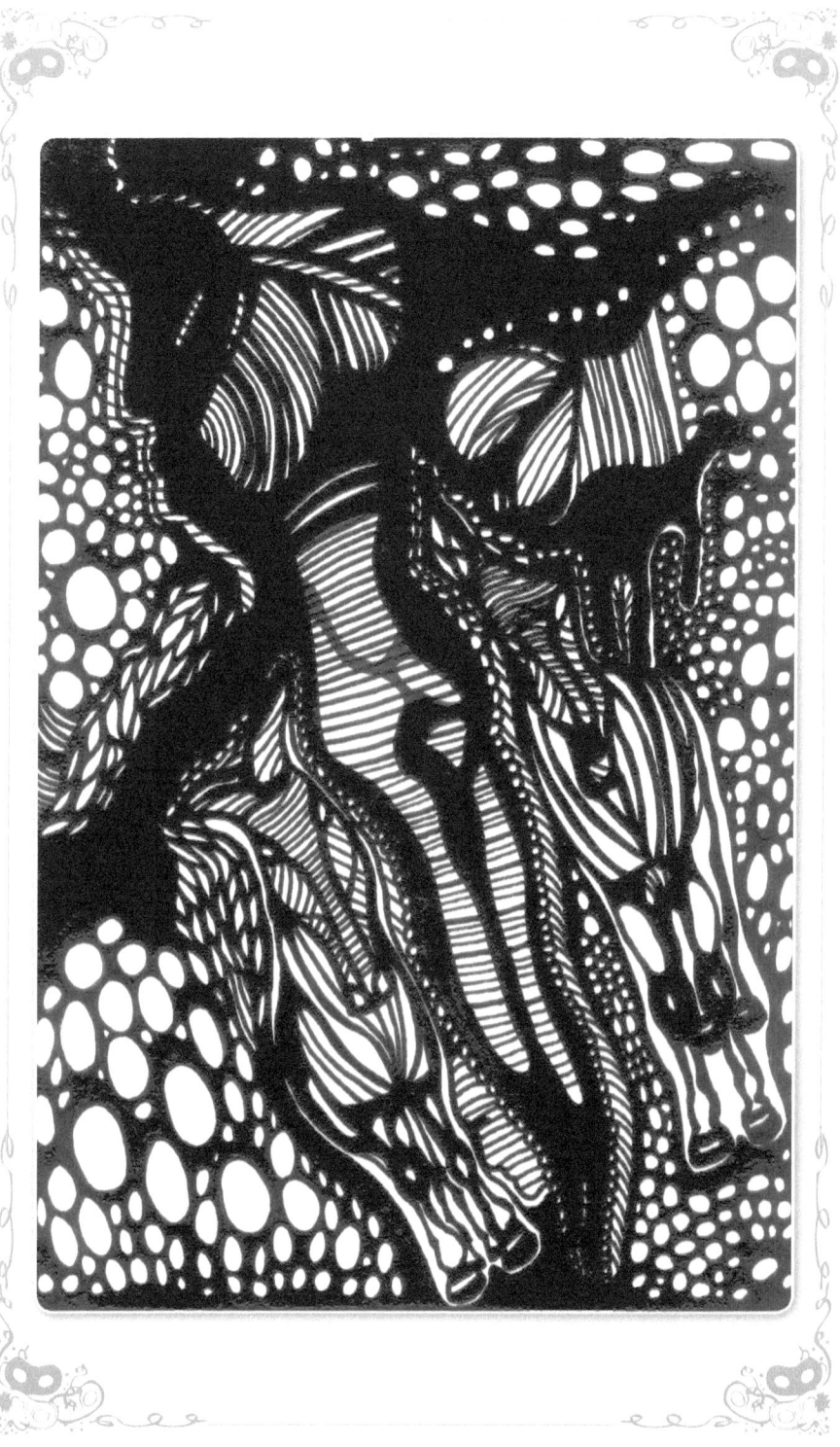

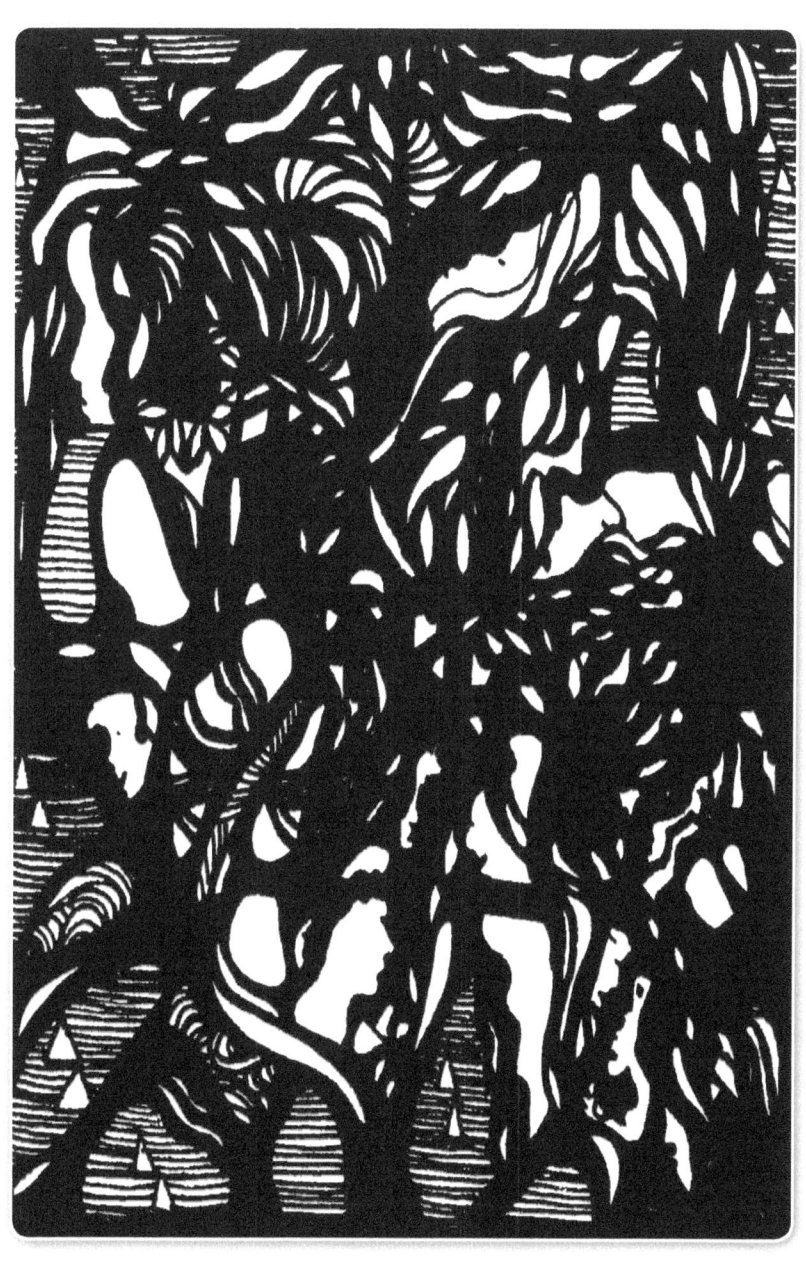

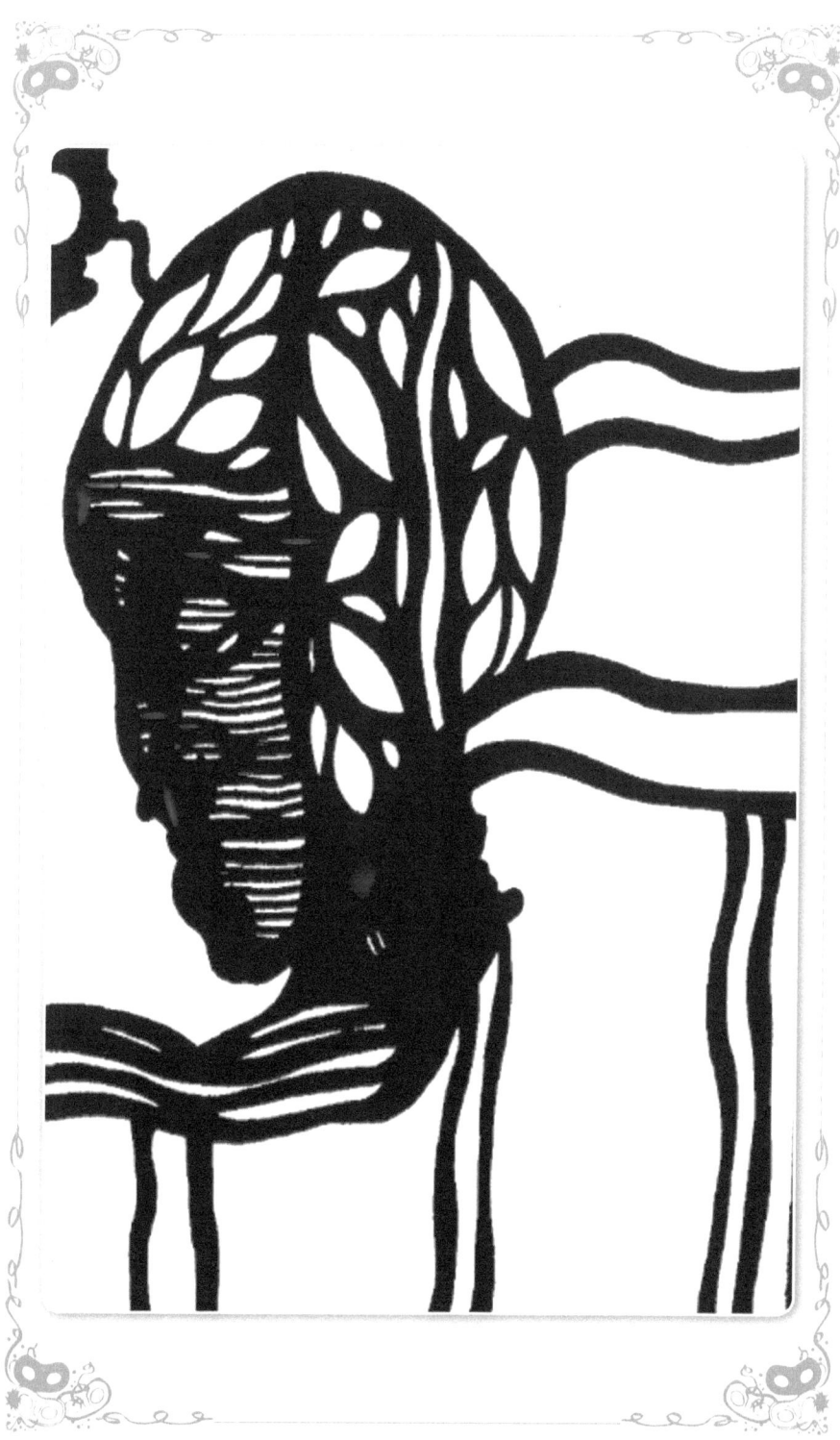

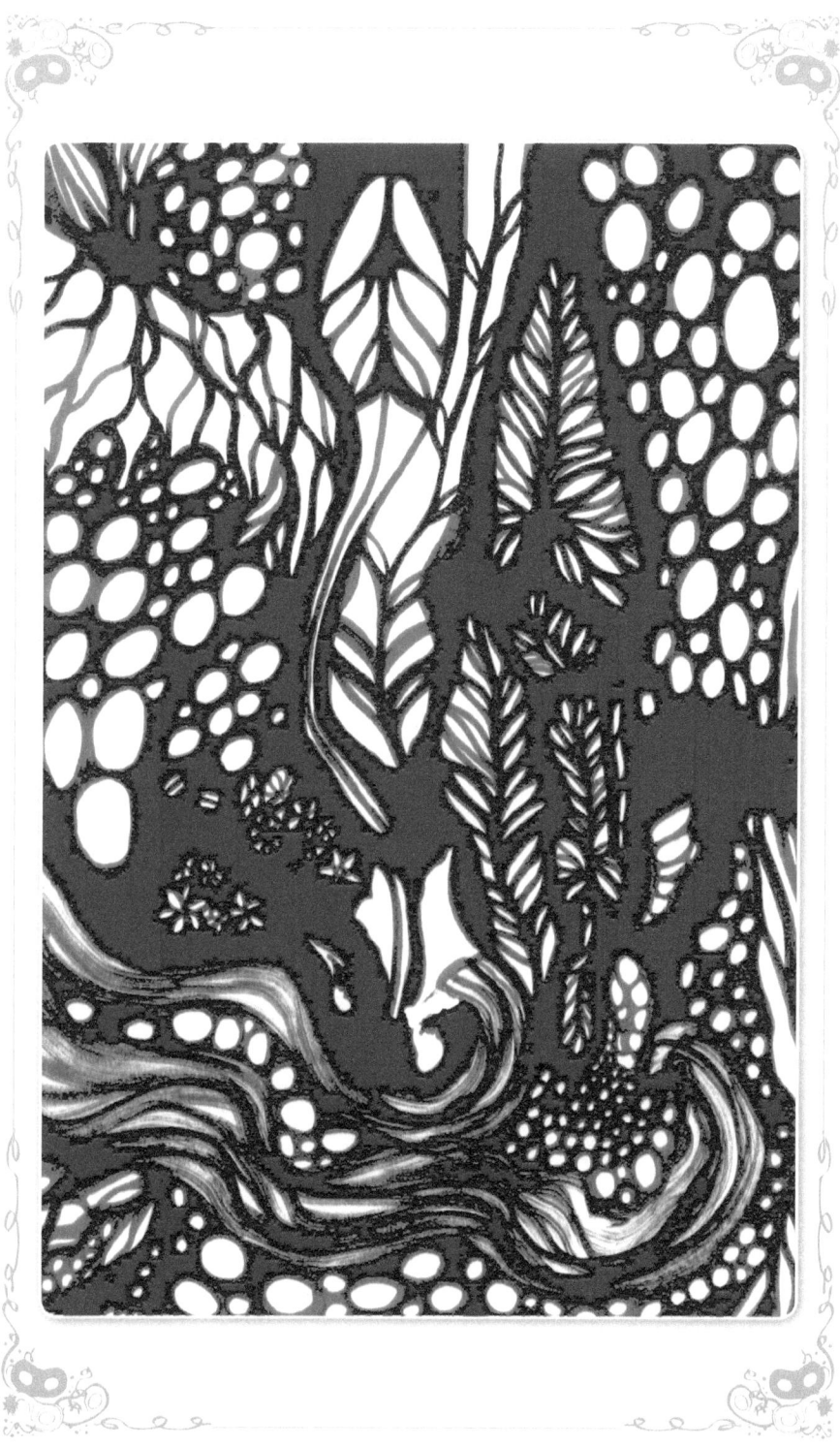

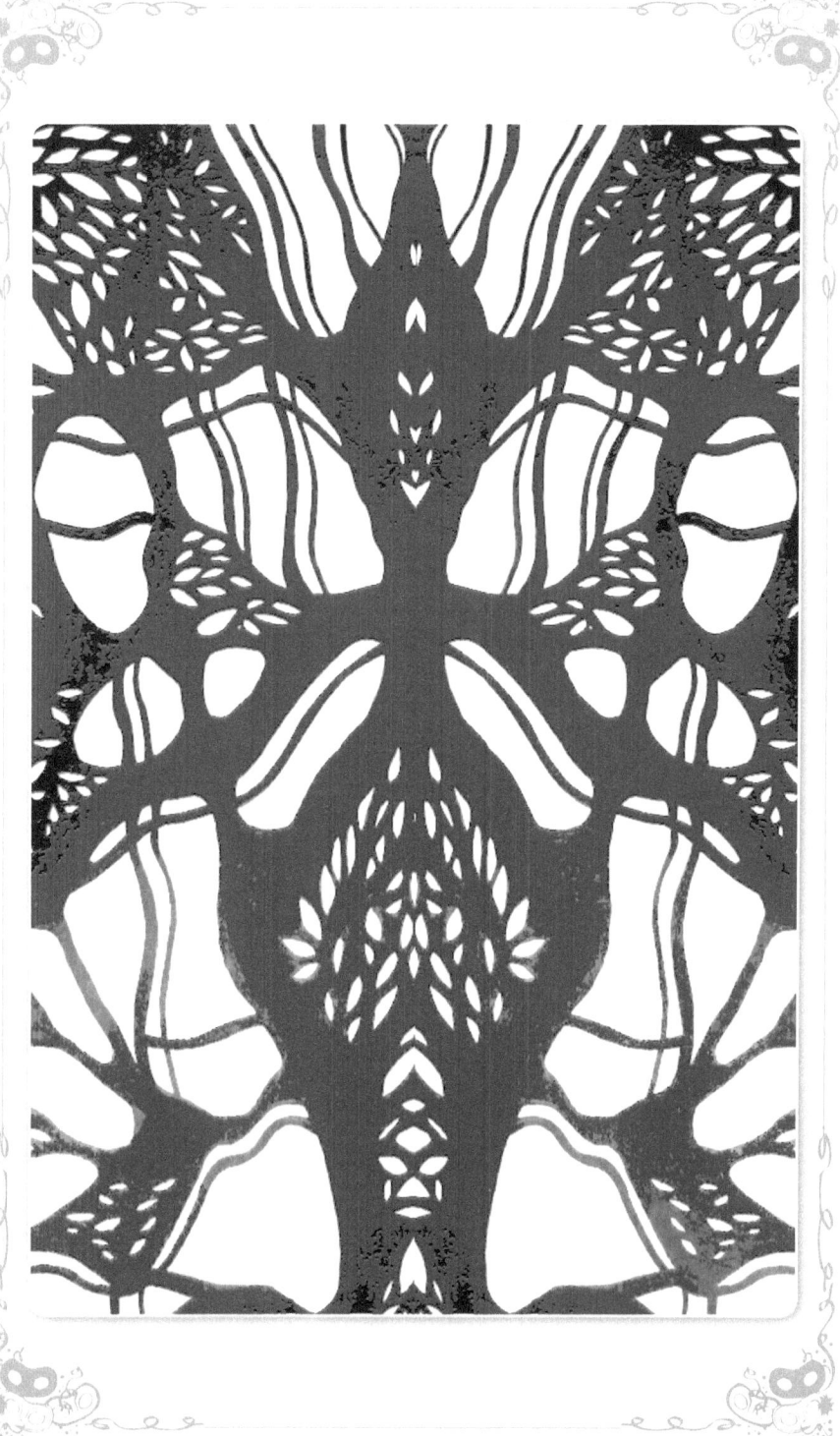

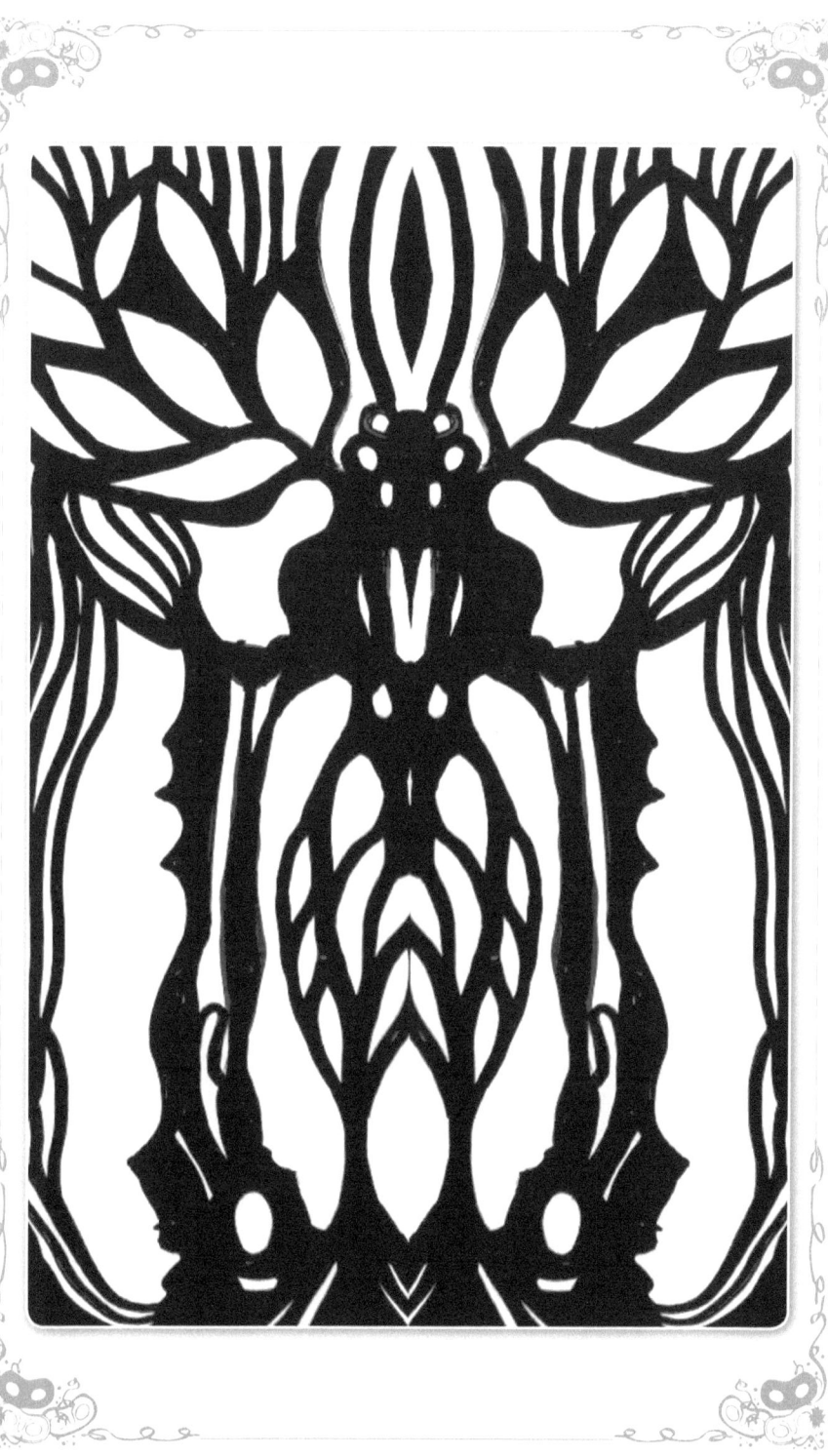

www.ingramcontent.com/pod-product-compliance
Lightning Source LLC
Chambersburg PA
CBHW021043180526
45163CB00005B/2266